WIDE OPEN

PHOTOGRAPHS BY LINDA McCARTNEY

wide

PHOTOGRAPHS BY LINDA McCARTNEY

open

FOREWORD BY PAUL McCARTNEY

A Bulfinch Press Book

Little, Brown and Company

Boston · New York · London

Foreword

I used to joke with Linda, that by marrying me, she had "ruined her career." What I meant was that people's perception of her would inevitably change from fine photographer to wife of a celebrity.

Although she wasn't particularly worried by this, I feel in some ways that it was true. It was sometimes incorrectly assumed by critics that her wonderful pictures of '60s musicians were due to her connection with me, even though most of her best photographs from that period were taken before we met.

One of the great things about Linda was that she was more interested in taking pictures than in what others thought of her. So over the years she continued to shoot enthusiastically whatever caught her eye.

Her interests ranged from portraiture to landscapes, flowers, animals, children, and much more.

For some photographers one of these subjects would have been enough, but in Linda's case her infectious enthusiasm knew no bounds.

I feel that sometimes this created another problem of perception for observers of her work. She is not easy to "pigeonhole"; nor would she have wanted to be.

Had she concentrated solely on portraits of musicians, it might have made it easier for people to grasp.

Had she devoted her time to landscapes only, it would have simplified the process of categorizing her, but her interests were just too wide for that.

We know Ansel Adams for his famous landscape photography, or Irving Penn and Richard Avedon for their fashion work, but with Linda it is not so easy to pin down her genre.

More recently her work has been shown, as in *Wide Open,* in a more thematic way, and I believe this may help people to understand just how talented a photographer she was.

Her honesty shines through all the images she produced, and her general lack of artifice is continually refreshing.

I feel that in time many will come to realize the vast scope of her work, unclouded by this "celebrity connection" and will understand what I have seen for many years – that she simply was one of the best photographers of our generation.

I would sometimes wonder why she didn't shoot thirty-six versions of a subject like so many photographers I had been used to, but was always delighted when she explained with a smile that it wasn't necessary.

"No, I got it."

She knew.

The body of work that now exists is a fine legacy, and a beautiful testament to a unique and rare talent that was, and still is, my lovely Linda.

Paul McCartney

Introduction

Several years ago I was given a group of Linda McCartney's photography books by a friend of mine as a gift. Having only known Linda's *Sixties* book, I was interested to see the other work.

I took the books home, sat in a quiet spot, and was mesmerized by Linda's pictures! I looked at the pictures again and again over the course of many months and decided that we must show these pictures at my gallery.

Linda McCartney: The Sixties and Sun Prints (June 1995) was a wonderful show that included hand-made sun prints and stunning platinum prints of still lifes and landscapes with a group of portraits from the *Sixties* book. Not only did this show illustrate Linda's continuing mastery of a variety of photographic processes, it showed her desire to evolve as an artist, with a cohesive sense of honesty and artistic clarity.

In preparing for the *Sixties and Sun Prints* show, I kept thinking, there must be more pictures that that we haven't seen, and we've got to see them!

Last September, I spent time with Linda, in England, and quite literally looked at almost every picture she had made in the past 30 years. I was astonished by what I saw!

Picture after picture, I was struck by Linda's keen eye toward composition, her inherent sense of objectivity, and the timelessness of the images. Seeing all of the photographs at one time gave me an appreciation of Linda's evolution as an artist. There was a tireless energy and commitment to the medium, supported by a strong desire to keep experimenting and growing. Through all of this emerged a singular vision, an openness, a feeling of positive energy behind each of Linda's images.

Ultimately, I feel it is this openness and freedom, backed by years of experimentation and mastery of technique, that allowed Linda to express herself in such a complete, confident way.

To me, it is appropriate that this period in Linda McCartney's life as an artist be characterized as *Wide Open*, the title of this exhibition of her work.

The pictures in this show have been culled from many, many years of work. Work covering a wide variety of processes and subjects: bromide and photogravure still lifes, platinum print landscapes, and Polaroid transfers. These photographs are unified by Linda's unique and honest vision - a vision that was *Wide Open*, both figuratively and spiritually, for all of us to experience.

There are landscapes of the Sussex countryside, the beach in East Hampton, the coastline of Brazil, and others that invite the viewer to dream and rest in the peacefulness of such imagery, and appreciate how precious our natural resources are. There are intimate still lifes- slices of everyday life: a teapot, a maple leaf, a collection of sea shells - composed perfectly, artistically, and frozen in time for each and everyone's interpretation.

Linda's œuvre of work is monumental in depth. This exhibition is only a small selection of images that need to be shown. After looking at the whole body of work, and the evolution of Linda McCartney as an artist, it is a privilege to present this work for all to enjoy and contemplate. Indeed, there are many more exhibitions waiting in the wings, for Linda's vision truly was *Wide Open* and we are grateful that her legacy as an artist will continue to inspire us all.

Bonni Benrubi

June, 1998

written on the occasion of the exhibition of these photographs in New York City

1

Mist in the valley 1984

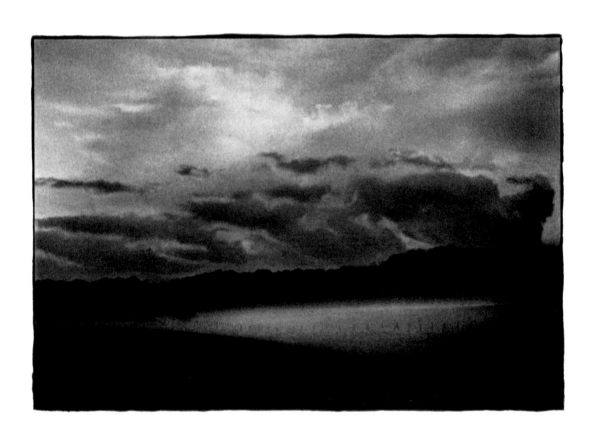

Forest moon 1985

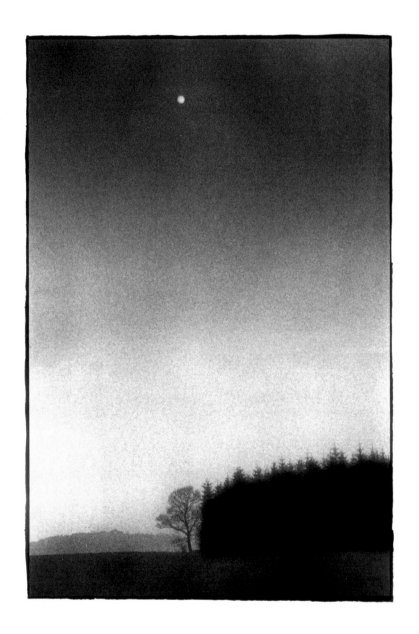

Oak in mist 1985

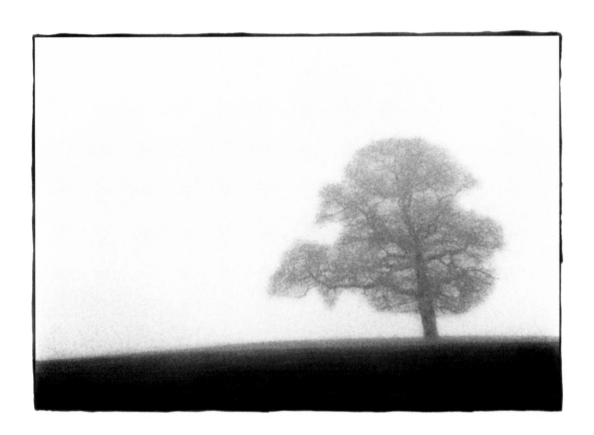

Misty lane 1985

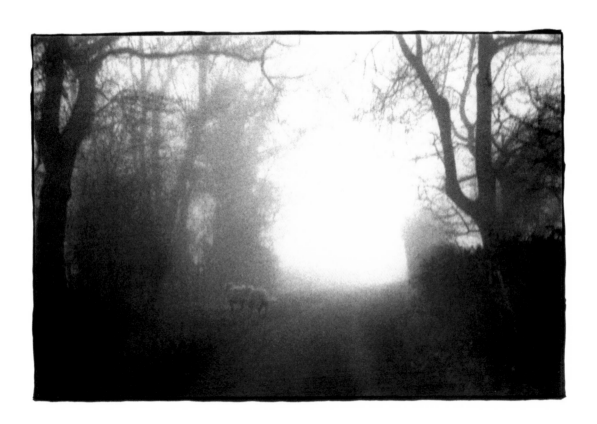

Lone horse rider 1985

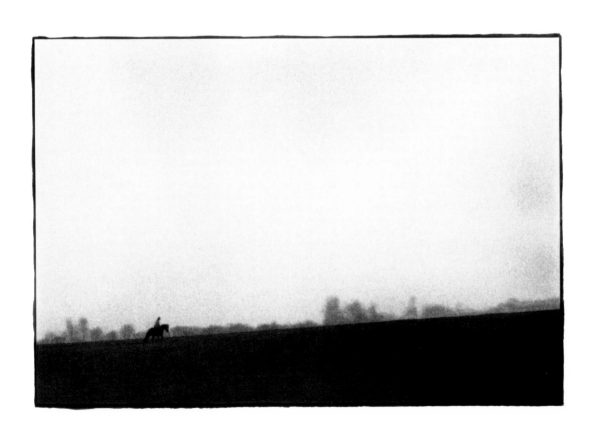

Oast landscape 1986

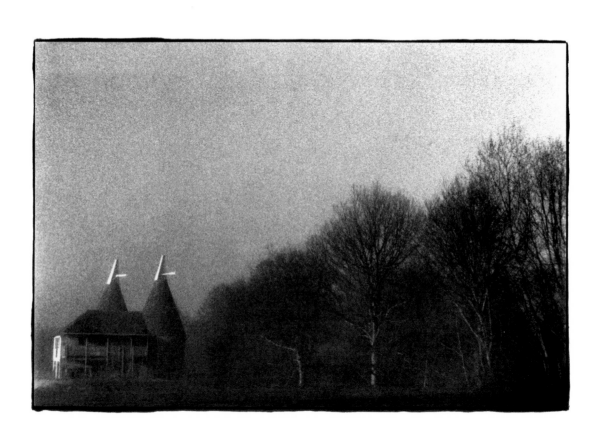

Fairlight Church 1986

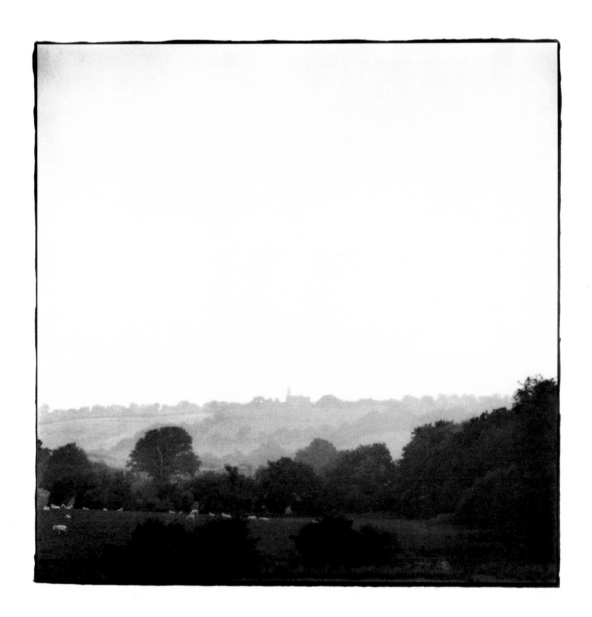

Two Romney sheep 1987

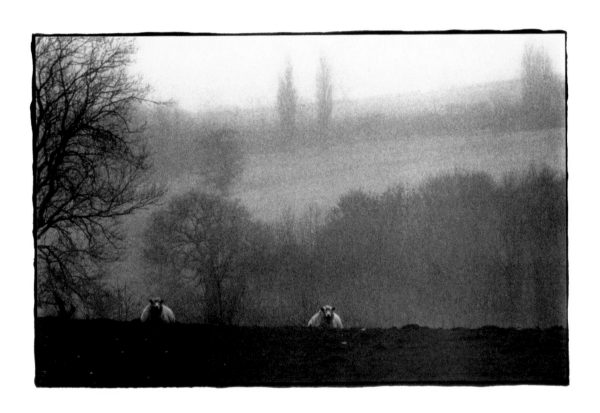

Misty Sugar Loaf 1990

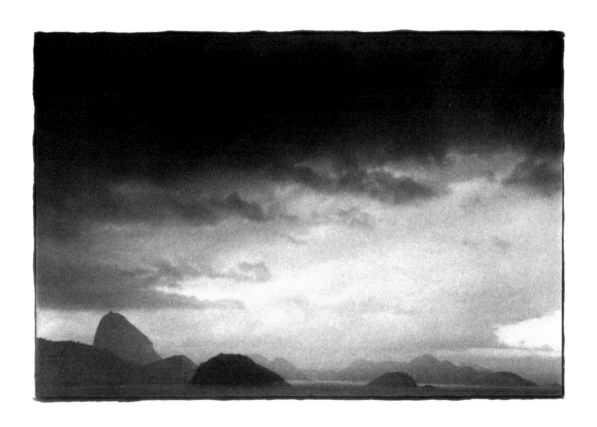

Stallion and standing stone II 1996

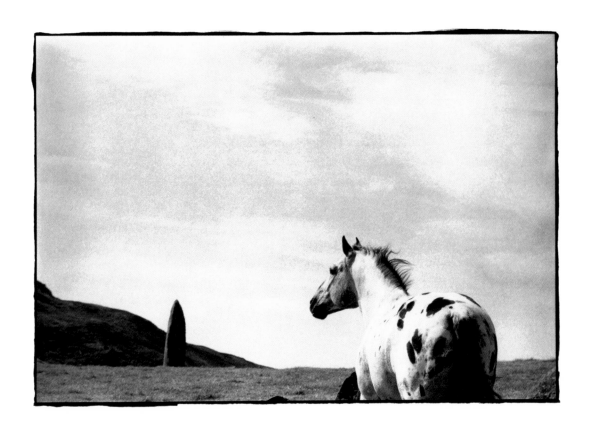

Sand sea sky 1995

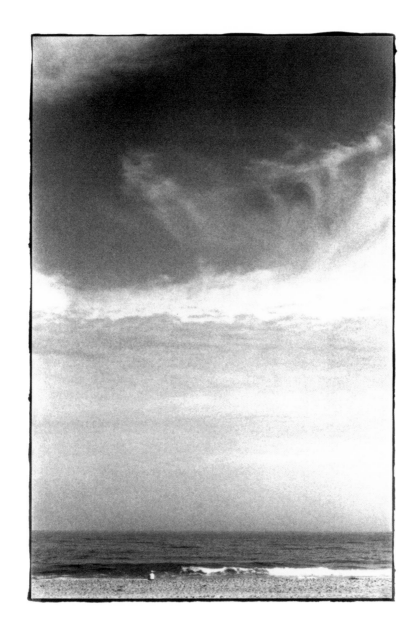

2

Clouds 1976

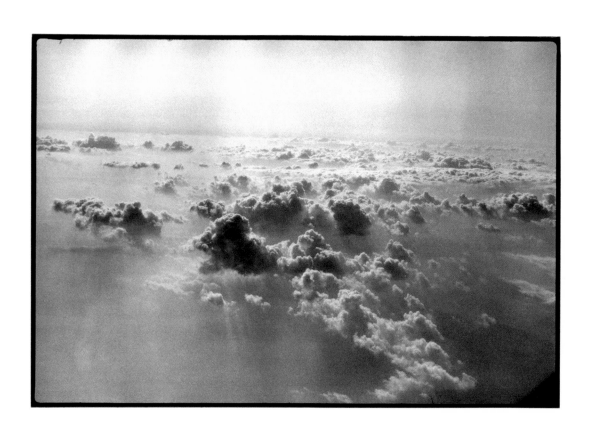

McCartney rose glass II 1993

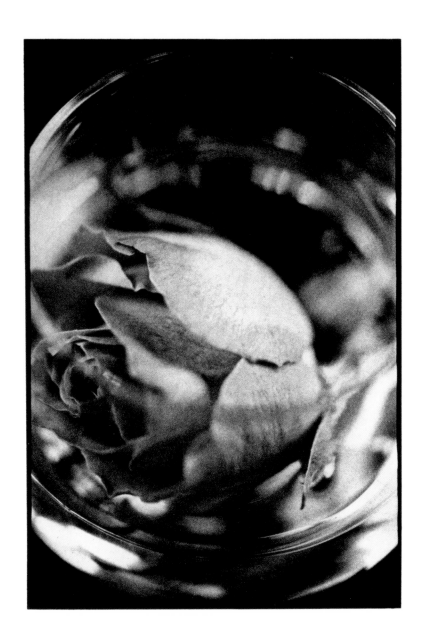

Sunflower head 1993

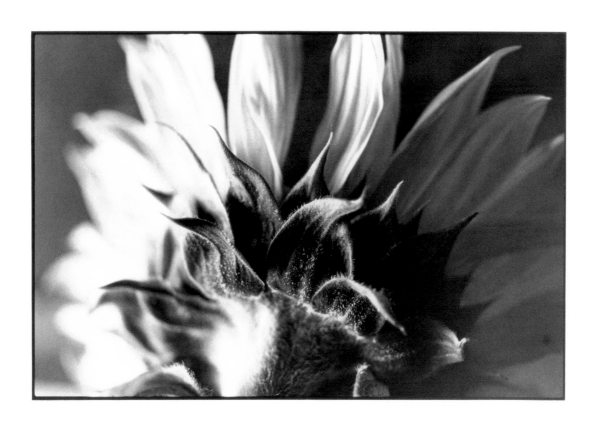

Cactus flower 1993

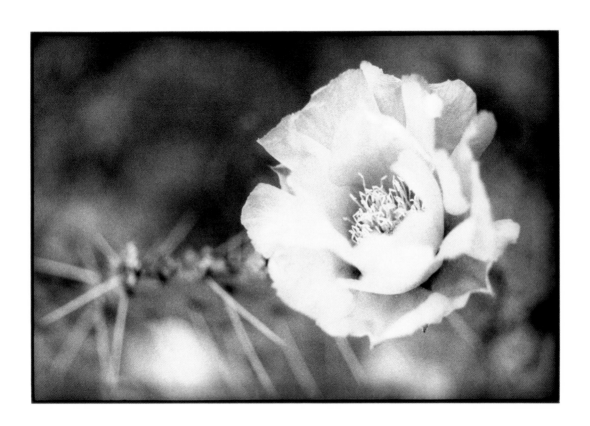

Prickly shadows II 1994

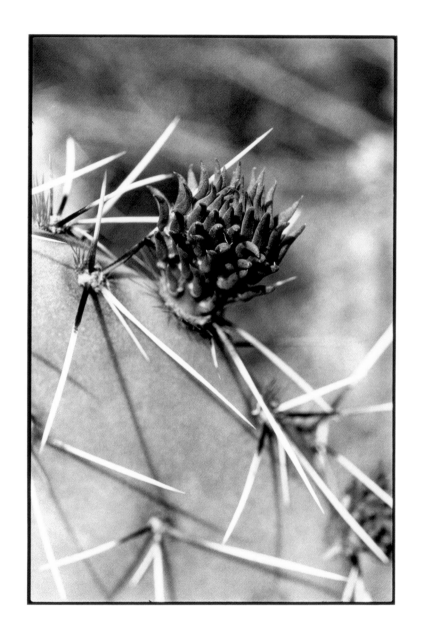

Wooden bowl Indian wood cuts 1994

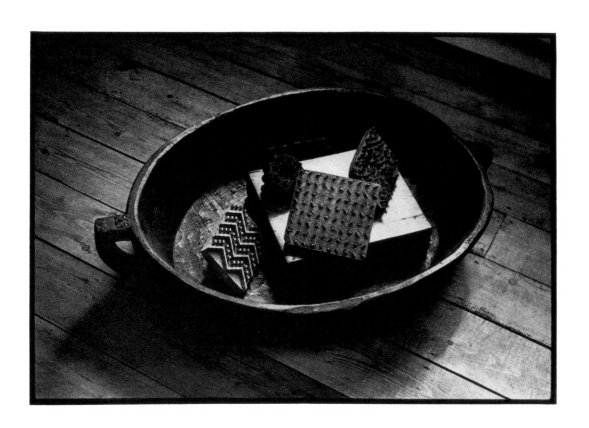

Table top shells 1996

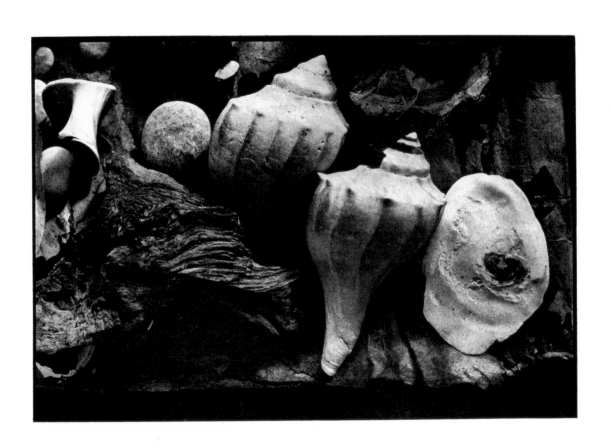

Ap and shadow painting 1996

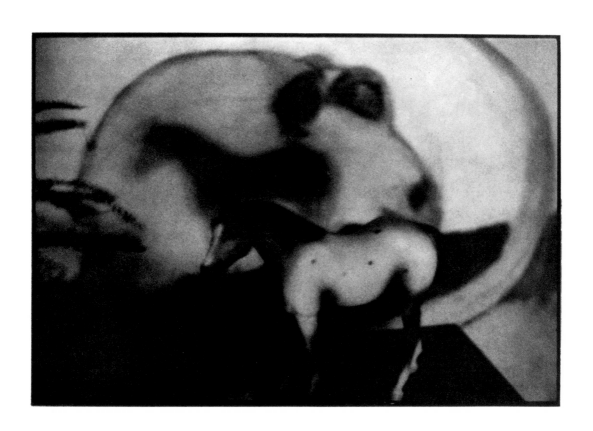

Kew ferns 1998

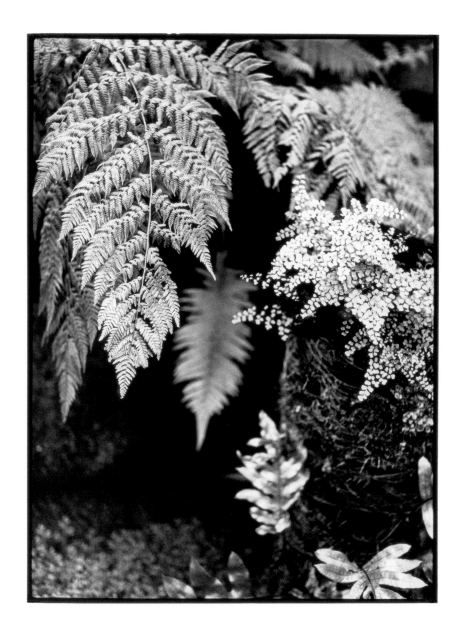

3

Shadow earth 1990

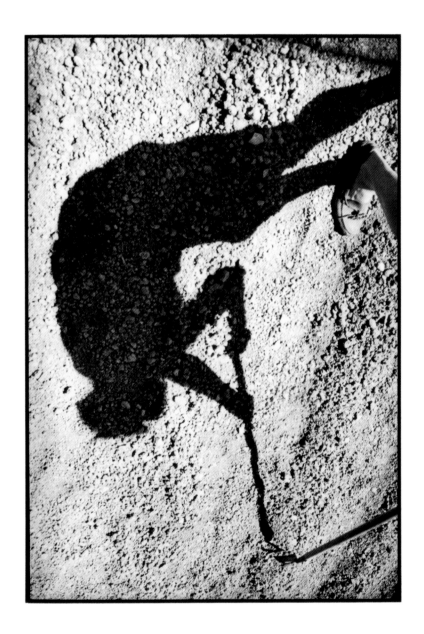

School score 1991

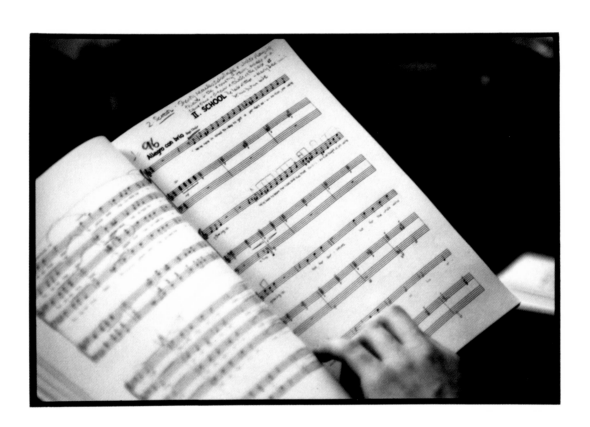

A major spectacle 1992

Shadow glass 1994

Mushrooms 1995

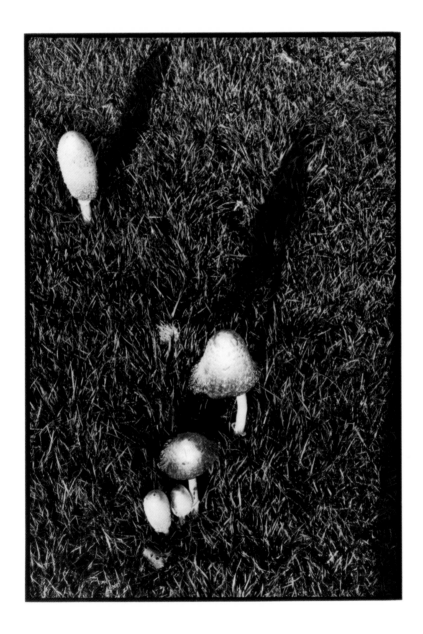

Jarman's trumpet 1995

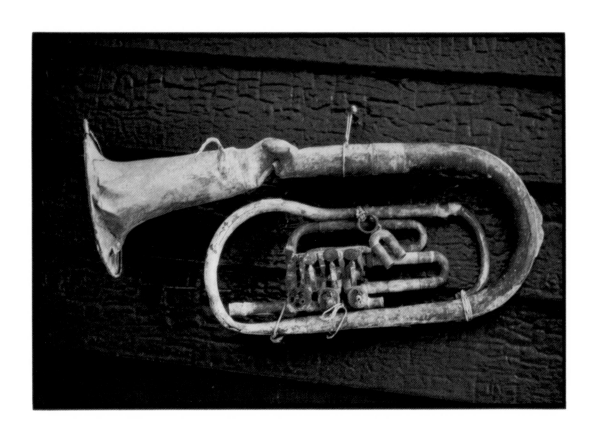

Through a glass teapot 1996

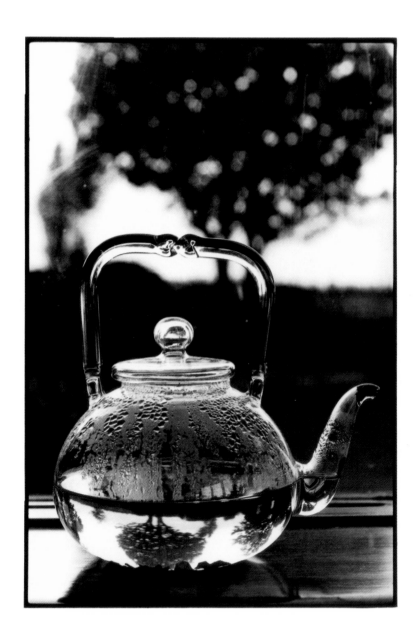

Bacon's easel 1997

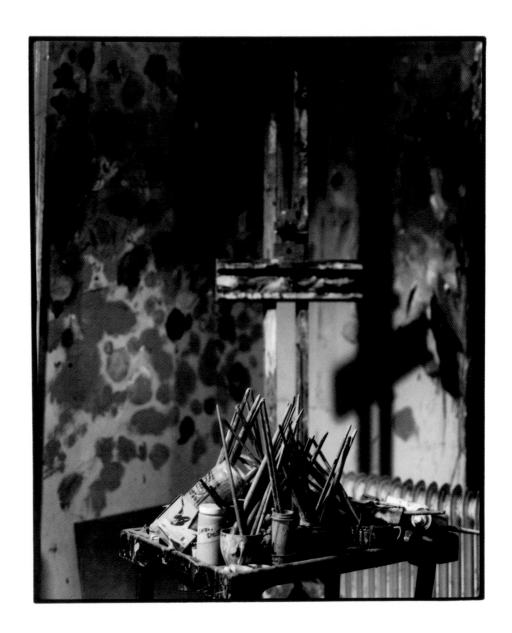

4

Century 1969

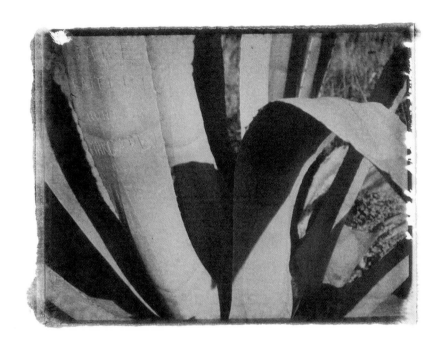

Pink roses 1974

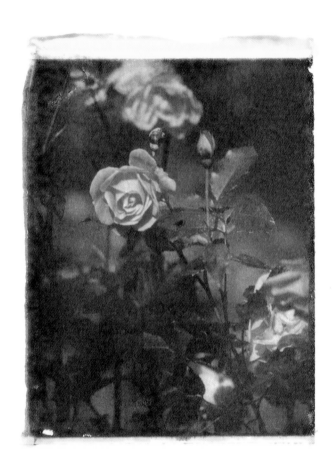

Blue tit on urn 1978

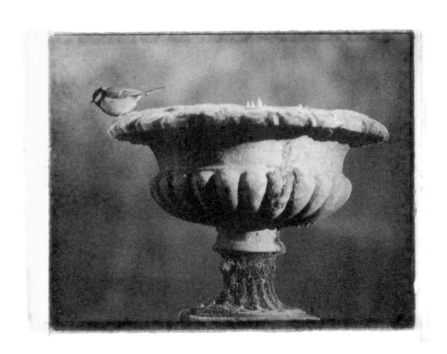

Red 2 lips 1979

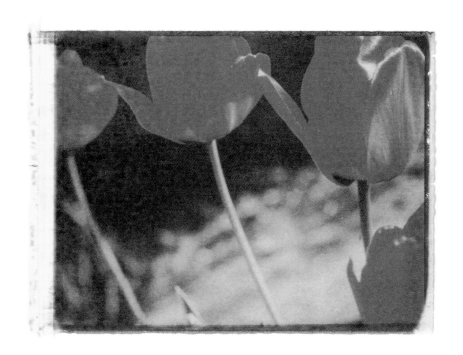

Winter rose II 1980

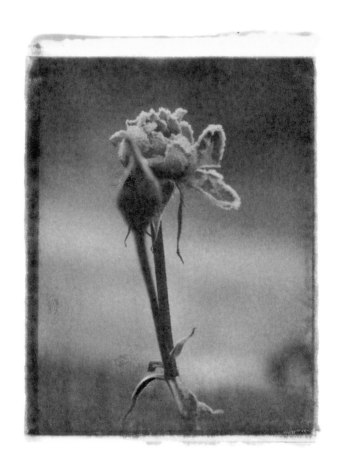

Lupins 1986

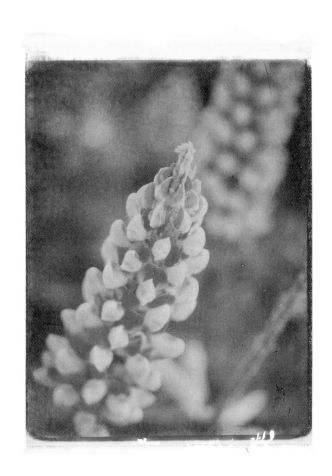

Foxgloves 1986

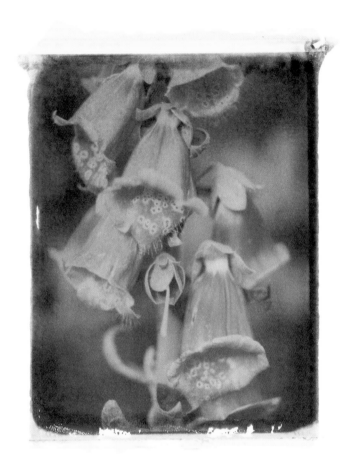

Poppy heads 1986

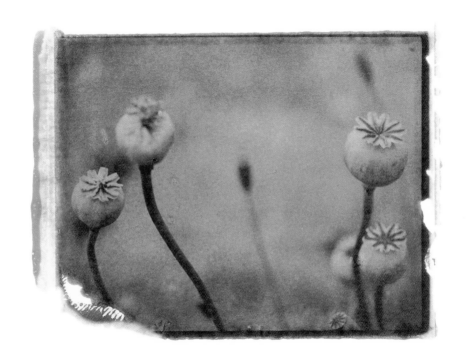

Several autumn maple leaves 1996

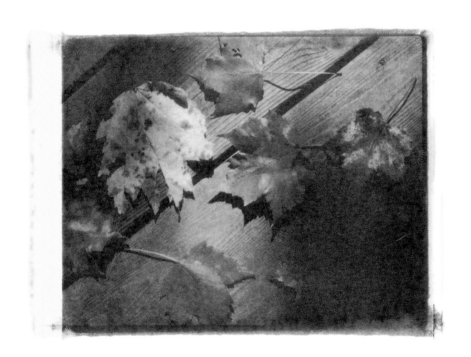

Two autumn maple leaves 1996

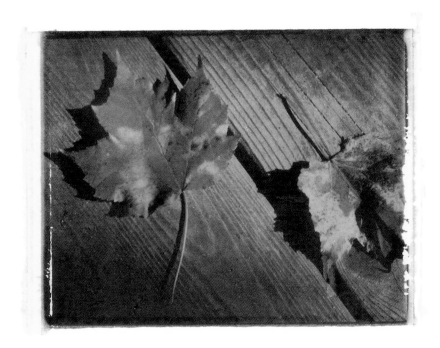

List of plates

1

Platinum prints

on mould-made paper *Arches Aquarel*

Paper size: 22" x 30"

Image size: 13.5" x 20" except no. 6: 18" x 18"

1 Mist in the valley, England 1984
2 Forest moon, England 1985
3 Oak in mist, England 1985
4 Misty lane, England 1985
5 Lone horse rider, England 1985
6 Oast landscape, England 1986
7 Fairlight Church, England 1986
8 Two Romney sheep, England 1987
9 Misty Sugar Loaf, Brazil 1990
10 Stallion and standing stone II, Scotland 1996
11 Sand sea sky, USA 1995

2

Photogravure prints

on mould-made paper *Somerset TP*

Paper size: 20" x 24"

Image size: 11" x 14" except no. 20: 9.5" x 12"

12 Clouds 1976
13 McCartney rose glass II, England 1993
14 Sunflower head, England 1993
15 Cactus flower, USA 1993
16 Prickly shadows II, USA 1994
17 Wooden bowl Indian wood cuts, England 1994
18 Table top shells, USA 1996
19 Ap and shadow painting, England 1996
20 Kew ferns, England 1998

3

Silver-bromide prints

Paper size: 11" x 14"

Image size: 8" x 12" except no. 28: 9.5" x 12"

21 Shadow earth, England 1990

22 School score, England 1991

23 A major spectacle, England 1992

24 Shadow glass, USA 1994

25 Mushrooms, England 1995

26 Jarman's trumpet, England 1995

27 Through a glass teapot, England 1996

28 Bacon's easel, England 1997

4

Polaroid transfers on cartridge paper

Paper size: 8.25" x 11.75"

Image size: 3" x 4"

29 Century, Portugal 1969

30 Pink roses, England 1974

31 Blue tit on urn, England 1978

32 Red 2 lips, England 1979

33 Winter rose II, England 1980

34 Lupins, England 1986

35 Foxgloves, England 1986

36 Poppy heads, England 1986

37 Several autumn maple leaves, England 1996

38 Two autumn maple leaves, England 1996

Previously published in a limited edition on the occasion of
the "Wide Open" exhibition at Bonni Benrubi Gallery, New York, 1998.

First Edition

US ISBN 0-8212-2596-0
UK ISBN 0-316-85046-2
Library of Congress Catalog Card Number 98 - 75607
A CIP catalogue for this book is available from the British Library

Published simultaneously
in the United States of America by Bulfinch Press, an imprint and trademark of Little, Brown and Company (Inc.)
and in Great Britain by Little, Brown and Company (UK)

Book design and production by Roger Huggett | Sinc
PRINTED AND BOUND IN GERMANY

Linda McCartney's work is represented by Robert Montgomery & Partners, London
Cover: *Misty Sugar Loaf, Brazil 1990*
Jacket: [FRONT] *Clouds 1976*, [BACK] *Through a glass teapot, England 1996*

For the exhibition:

Personal assistant to Linda McCartney: Mary McCartney

Platinum prints:
Printed by Paul Caffel | 31 Studio

Photogravure prints:
Plates made by Hugh Stoneman | Stoneman Graphics Limited
Printed by Mike Ward | Atlas Print Studio

Silver-bromide prints:
Printed by Pete Trew

Polaroid transfers:
Printed by Zoë Norfolk